IT'S NEW!

A CATALOG OF THE COOLEST TOYS **NEVER** MADE!

TOYBOX
TIME MACHINE

CONCEIVED AND ILLUSTRATED BY
MARTY BAUMANN

IDW
PUBLISHING

COLLECTION EDITORS
JUSTIN EISINGER
AND ALONZO SIMON

PUBLISHER
TED ADAMS

ISBN: 978-1-63140-907-3 20 19 18 17 1 2 3 4

TOYBOX TIME MACHINE: A CATALOG OF THE
COOLEST TOYS NEVER MADE. JUNE 2017. FIRST
PRINTING. © 2017 Marty Baumann. All Rights Reserved.

Ted Adams, CEO & Publisher
Greg Goldstein, President & COO
Robbie Robbins, EVP/Sr. Graphic Artist
Chris Ryall, Chief Creative Officer
David Hedgecock, Editor-in-Chief
Laurie Windrow, Senior VP of Sales & Marketing
Matthew Ruzicka, CPA, Chief Financial Officer
Lorelei Bunjes, VP of Digital Services
Jerry Bennington, VP of New Product Development

For international rights, please contact
licensing@idwpublishing.com

Become our fan on Facebook facebook.com/idwpublishing
Follow us on Twitter @idwpublishing
Subscribe to us on YouTube youtube.com/idwpublishing
See what's new on Tumblr tumblr.idwpublishing.com
Check us out on Instagram instagram.com/idwpublishing

How did they KNOW... what we wanted BEFORE we did?

Were they psychic? Did the designers who created the innovative and outlandish toys and games of the 1950s and '60s possess that facility? Or perhaps, to invoke an overused expression, they were kids at heart. More likely they were just plain brilliant. Whatever the explanation, a generation found their creations irresistible. Christmas catalogs, store displays, television ads and comic books once overflowed with depictions of alluring toys that kids like me just couldn't live without.

Toybox Time Machine is a tribute to the unbridled imaginations and madcap design and illustrative skills of the toy creators who drew inspiration from the robots, spies, movie monsters and military men that kids adored, as well as the limitless possibilities of the space age. The top toymakers employed some of the most talented and free-thinking designers then working. And somehow these geniuses knew what we wanted before we did!

And they NEVER ran out of ideas! Mr. Machine begat The Great Garloo — not to mention Son of Garloo — with Robot Commando hot on his heels. Before long, the robots were "rockin' and sockin'!" And then there was Big Loo. It was as though his creators decided to cram every gadget that came to mind into one grotesque action figure. He had a built-in scanner, his eyes lit up, one hand was a massive claw while the other shot projectiles. He boasted a water ray, a magnetic compass, gave off a sonic signal and ... he TALKED! To top it all off, this maniacally grinning, pointy-headed Moonbot's body was itself a rocket! Only G.I. Joe, Johnny West and Major Matt Mason combined could stop him! And, one word: "Plastigoop."

Within these pages you'll discover what are undoubtedly the greatest toys NEVER made (but wouldn't your world have been a better place if they had been?). I hope this volume recaptures something of an innocent era of boundless commercial creativity.

Throughout my years of experience as a commercial illustrator I mined the reserves of mid-century design. Likewise my contributions to the visual development of such films as *Toy Story 3*, *Big Hero 6*, *Zootopia*, the Disney/Pixar *Cars* and *Planes* franchises and my role in the creation of Disneyland attractions such as Cars Land, have afforded me an enviable insight into how the designs of the past influence the imaginations of audiences today. *Toybox Time Machine* is my opportunity to coalesce all my design influences and invocate some of my happiest memories — and possibly some of yours! Call them kitsch, corny, kooky, garish, whimsical, outlandish — I'll accept any of those terms as high praise!

MANY THANKS to my incredible wife and editor-for-life, Pattie; Jim Steranko; Byron Howard; The Great Jack Davis; Joe Sinnott; Steve Conley; Chris Ryall; Alonzo Simon; Justin Eisinger; Jeff Webber; and the whole IDW gang for believing in this project.

ARGILL

MR. ATOMIC

FRICTION GEAR MECHANISM

NEW ACTION TOY

— WALKS
— STOPS
— RAISES ARMS
— FLASHING EYES

BATTERY DRIVEN MOTOR

POWERED BY TWO
"D" BATTERIES (not included)

comics COMPLETE with...

a foreword by JIM STERANKO!

Some things never change!

I'm not suggesting that's a good thing, but it may have some residual advantages. It's no secret that I emerged standing upright from an entertainment background that ranged from performing hazardous escape stunts in the Houdini style to playing for twelve years through the dawn of the rock 'n' roll era — and am still uncertain which was more dangerous. All that to say when I moved on to advertising design, commercial illustration, and publishing, the shock of exiting the spotlights of the public stage to the seclusion of a dimly-lit studio may have been somewhat oppressive.

Fortunately, there were a few extenuating options, one of which was making personal appearances at pop-culture events across the country and even around the world. I still recall one that played out in the distant past. The prime perk of those appearances was connecting with strangers who ran the gamut from famous film stars to wino wannabes — but who shared a Niagara of commonalities. That's how I connected with Marty Baumann, and, in retrospect, I believe it was every bit as unavoidable as it was unpredictable.

Rather than asking me what went through my mind being dropped to the bottom of a river cocooned in a couple hundred pounds of steel chains and locks or having the audacity to define the adventures of Captain America in the wake of Jack Kirby, he engaged me in music-driven conversation. I was cool with that because my preference runs from classical to jazz. So, I was up to playing his game. In the tempest of meeting thousands of new fans and friends, it was easy to determine he was a musician. And that's why I thought I'd pinpoint the depth of his expertise — with a *single* question.

"What's your favorite number by the man responsible for the popularization of the passing chord?"

It's the kind of question that defines those who know and those who don't. He knew it, and he knew that I knew it, because the term passing chord isn't exactly in the lexicon of most musicians. And knowing who popularized the passing chord cranks up the quiz more than a few notches. And, considering how few recordings the musician who popularized the passing chord made *as a front man* could be the $64,000 question in the jazz spectrum.

"I don't think I have any special Tadd Dameron favorites," he said with a casual demeanor that played like it had been written in a film script. And that was our opening gambit — two guys laying down a challenge and meeting it — of a friendship that has miraculously endured for more decades

than either of us care to admit.

Some things never change!

To his friends and enemies, Marty B is known as a cultural encyclopedia (he can spot the difference between a sea bass and a Saul Bass at fifty yards), specializing in cinema, music, comicbooks, and pop illustrators, particularly those of the mid-century, when he was an impressionable kid getting sand kicked in his face!

It's obvious a good span of his misspent youth was squandered in the World of UPA, Gerald McBoing-Boing, Mister Magoo, and company. And a good span of his misspent adult life has been squandered redesigning that world — to make it all his own. And that's what *Toybox Time Machine* is all about — a radical justification of his affection, devotion, and obsession for the Distressed Line Art of Alice and Martin Provensen, the Streamlined Cartoon Style of Bert and Harry Piel, the Expressionistic Line Texture of David Stone Martin, and the Modernist Cartoon Style of Rocky and Bullwinkle. And if any of those references are elusive, don't worry about it — you're either too young to remember or so old, you forgot!

If Marty had any tattoos, they'd undoubtedly be logos touting the names Marx, Hasbro, Mattel, Ideal, Remco, Hubley, Whitman, and Kenner! (Hey, I haven't looked!) There is an unsubstantiated rumor that at one point in his life, he had difficulty choosing between girls and the Great Garloo — and I won't even mention his psychoerotic fixation with Plastigoop!

What may not be apparent in these pages, but no less defining of his extraordinary creative persona and professional drive, are his musical credits — which are as exhausting as they are extensive. As an R&B singer/guitarist onstage for more than 40 years, he has gigged with Hound Dog Taylor's Houserockers, Danny Gatton, Bobby "Blue" Bland, Jr. Walker and the All Stars, and Johnny Winter, among others. As a Walt Disney and Pixar illustrator-graphic designer, he has put his idiosyncratic brand on a host of films, including *Toy Story 3*, *Big Hero 6*, *Zootopia*, *Cars 2*, and *Planes*. His client list reads like a Who's Who in a graphic hot-shot's fantasy: Hasbro, Universal Studios, National Geographic, Scholastic Books, Nickelodeon, and *Mystery Science Theater 3000*, to skim only a few. And his most recent assignment was the visual development of Sir Paul McCartney's animated film feature *High in the Clouds*.

Although I've never discussed it with him, I suspect that his predilection for '50s Retro Style is embedded in a desire to recapture certain moments of his adolescent years when he discovered the magic of store displays, television spots, comicbook ads, and Christmas catalogs, all rippling with the excitement of games and toys no kid could live without! It would not be stretching the truth to suggest that reading ads for this stuff was often more fun than playing with it!

Whatever the case, Marty's affinity for the wild, the wacky, and the weird became an irresistible force that lured him from a useful, meaningful life into one of absurdity and moral delusion. What's really surprising is that he turned a childhood fixation into an adult vocation. He became a commercial artist, honing and promoting his retro predilections into a position of unbridled power — as one of the field's most accomplished stewards of Mid-Century Cartoon Madness. As you riffle through the book, you'll be impressed at how simple it appears, a diabolic deception, not unlike the trapeze artist who throws a triple and makes it look so easy, every spectator is lulled into believing they could do it, too. The unquestionable mark of a pro. Good luck!

You'll find these pages replete with sharp compositional sensibility counterpointed by a zany sense of humor, an unbeatable combination that separates the men from the boys. Marty has expanded that honored tradition by investing his tropes and techniques into a tsunami of children's books, theme-park

installations, packaging design, broadcast promotions, and countless other venues that have been in our faces for decades. He has carried the substance and style closest to his heart into a new millennium, added his own creative riffs to the material, and presented it for our approval. This book may be his definitive statement.

I'm guessing G.I. Joe, Johnny West, and Major Matt Mason would be enthusiastic to salute those achievements by reconnoitering *Toybox Time Machine* and discovering a wealth of fabulous, retro treasures that never existed — until Marty and his boundless imagination envisioned them. I guarantee you'll have as good a time exploring them as he did creating them.

Some things never change!

Steranko

JIM STERANKO is one of the most controversial figures in contemporary culture, a visionary engaging a multitude of mediums, including films, graphic novels, interactive games, animated TV series, and electronic formats. He has had multiple careers as a musician, author, photographer, carnival fire-eater, publisher, illustrator, male model, art director, escape artist, and designer. As one of the prime architects of the Marvel Age, he infused elements of surrealism, op art, and a revolutionary narrative approach, which generated 150 original innovations that changed the direction of the narrative form. His mastery of visual storytelling made a longtime friend of filmmaker Federico Fellini, and led to major cinematic collaborations with Steven Spielberg, George Lucas, and Francis Coppola, among others.

HALF the FUN of DREAMING UP these TOYS...

...WAS CREATING the approximately 150 individual corporate logos that adorn the packaging of every toy, game and puzzle depicted. Each company name has a unique backstory (existing only in my head) to accompany its appearance. Employing the varied fonts (some of my own creation), color schemes and shapes to reflect the look of a particular year – ranging from, roughly, 1950-1966 – was nearly as big a challenge as creating the toys themselves. As mid-century design was and is a major influence on my artistic development, this task was particularly rewarding.

VIEWER IN EVERY PACK

FIG. 1

contents INCLUDE... an introduction by BYRON HOWARD!

As we created the vast animal world of Disney's *Zootopia*, we realized that in the human world, signage and advertising is everywhere. The same had to be true for the millions of mammals that call *Zootopia* home. But who do you call when you need literally hundreds of pieces of original art for animal billboards, animal magazine ads, animal posters and businesses?

Only one man had the artistic skill, the historical knowledge, and the uncanny ability to produce animal puns so good (or bad) that they hurt: Marty Baumann.

Little did I realize during our year-long collaboration on *Zootopia* that Marty and I shared a dark, secret addiction.

Philadelphia suburb, summer, 1974. In my parent's backyard, 5-year-old me stares goggle-eyed at a tiny plastic submarine that uses baking soda to plunge to the ocean floor of our inflatable wading pool.

My brain explodes.

That first hit I got off that submarine was my gateway to harder, more intense, mail-order toy experiences.

I tried everything I could get my hands on. Nothing was too extreme. Sea Monkeys, the Air Car Hovercraft, even X-ray Specs, magical cardboard glasses that allowed you to see through the clothes of unsuspecting passersby or glimpse the bones in your own hand! People tell me it was a trick, but I know what I saw.

Before Amazon Prime, kids like me and Marty would mail out our hard-earned cash for the desired toy and then have to wait 4-6 endless weeks for delivery. But, when the wait was over, the package that arrived was addressed not to your parents, but to YOU. No longer a child, you were now and forever a respected member of adult capitalist society.

Toybox Time Machine is Marty Baumann's leap back into a time that was with toys that weren't, but should've been. Looking through these pages of his extraordinary art will transport you back to an era when the closest thing to an iPhone 7 with Retina Display was the Spy Pen Radio. Only $3.75!

Money back if not delighted.

Byron Howard

BYRON HOWARD *is the Oscar-winning co-director of* **Zootopia***,* **Tangled***, and* **Bolt**

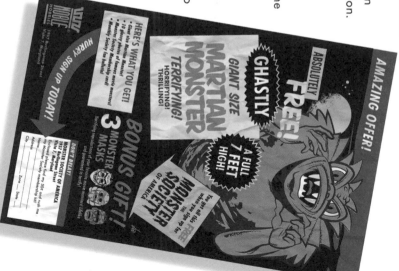

HT® toymakers

THE OFFICIAL AGENT OF M.O.D.™
SECRET MISSION ACCESSORIES SET

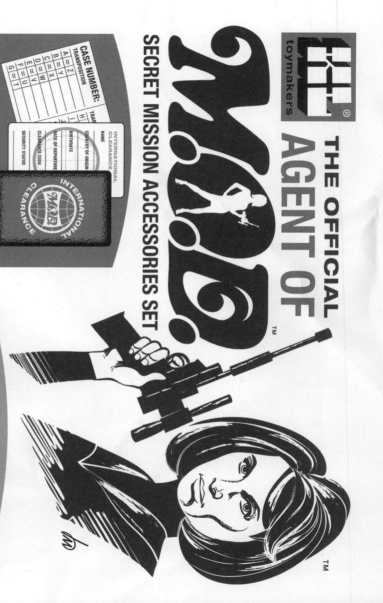

M.O.D. PASSPORT/CODE BOOK
WITH SPACE TO WRITE IN YOUR UNIQUE I.D. NO.

CASE NUMBER: TRANSPOSITION

A = Z	H =
B = Y	I =
C = X	
D = W	
E = V	
F = U	
G = T	

INTERNATIONAL CLEARANCE
NAME
COUNTRY OF ORIGIN
BIRTHDATE
DATE OF DEPARTURE
CLEARANCE CODE
SECURITY STATUS

INTERNATIONAL CLEARANCE
M.O.D.

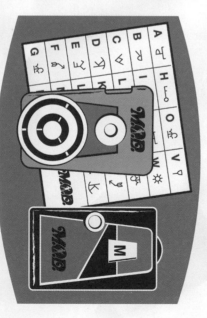

M.O.D. MINI-SKIRT & BOOTS
COMES WITH BLACK JUDO LEOTARD

HOLLY THORNE ACTION DOLL SOLD SEPARATELY

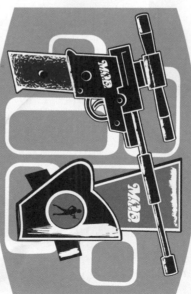

M.O.D. PISTOL & HOLSTER SET
WITH 15 "SURE-SHOT" PLASTIC SHELLS THAT SPRING-LOAD

M.O.D. COMMUNICATOR & DECODER
AMPLIFIES YOUR VOICE - TWO AA BATTERIES NOT INCLUDED

the "GREAT BIG" of

TALKING BOOK of AIRPLANES

Join Us for the Story of Flight

DIAL-A-PAGE TO HEAR

HEAVY, "NO-TEAR" PAGES

WASHABLE!

READ, LISTEN AND LEARN ALL ABOUT AIRCRAFT!

WEE-ART TOYS, INC.

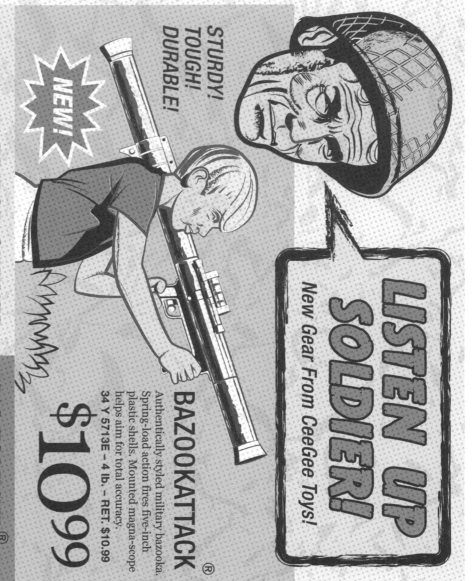

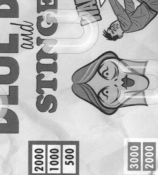

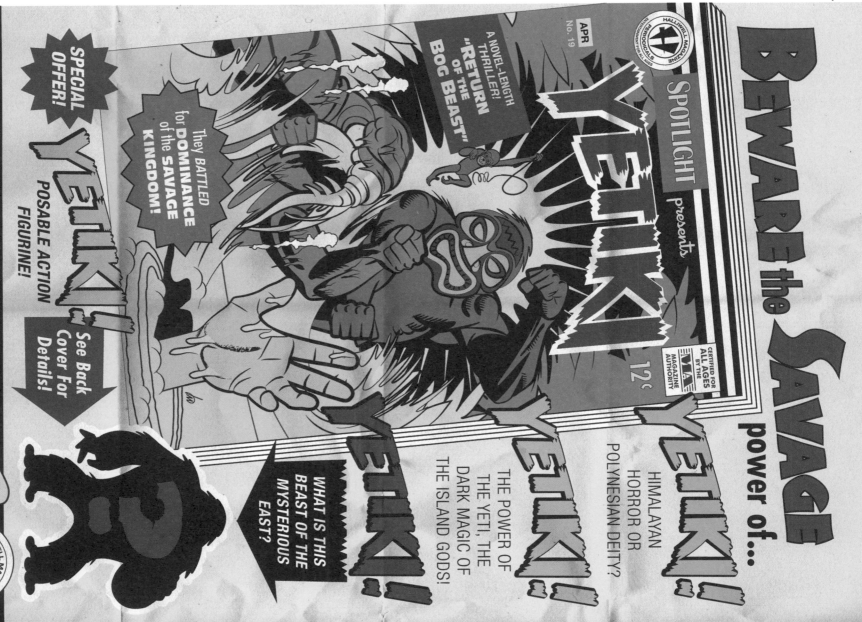

Blueline® toymakers

Bitsy FASHION DOLL

ALOHA Bitsy BONGO PARTY

PLAYSET INCLUDES
Mini Bongos
Tiki Statue
Bitsy Lotus
Print Dress
Instructional
Dance Record

INSTRUCTIONAL
DANCE RECORD
INCLUDED!

BONGO DRU! Party

STEREO UNBREAKABLE PLASTIC RECORD STEREO
Dance Instruction Record

BIG TOP BEAR ©

HEAVY QUALITY VINYL INFLATABLE "BIG 52 INCH"

BOP-IT BAG

YOU JUST CAN'T KNOCK DOWN THE FAMOUS

BIG TOP BEAR!

HE "POPS" RIGHT UP AGAIN!

BOP HIM AND YOU'LL SEE!

YOU'LL WANT ALL OF BIG TOP'S "BOP-IT BAG" CIRCUS PALS!

BOYS! GIRLS! GHOULS!

FABULOUS FEARSOME FUN FROM MARVELOUS MARTICO!

NEW!

presenting

MAD® *presenting* MONSTER MIXER

CRAZY MIX-AND-MATCH CARD GAME

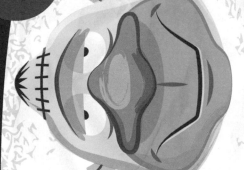

DOZENS OF CREEPY CRAZY COMBINATIONS!

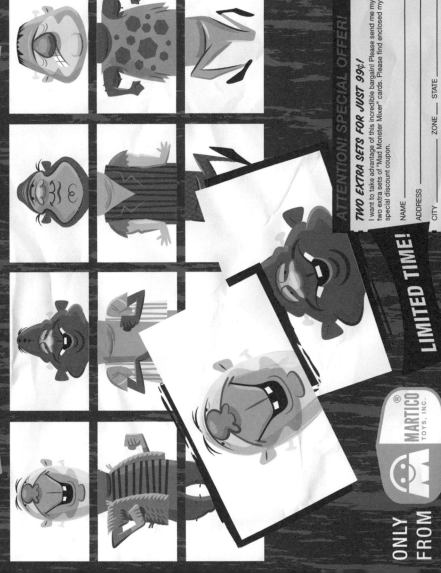

ONLY FROM

MARTICO® TOYS, INC.

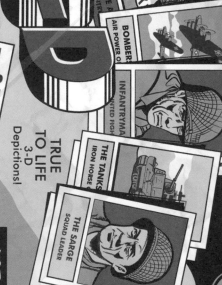

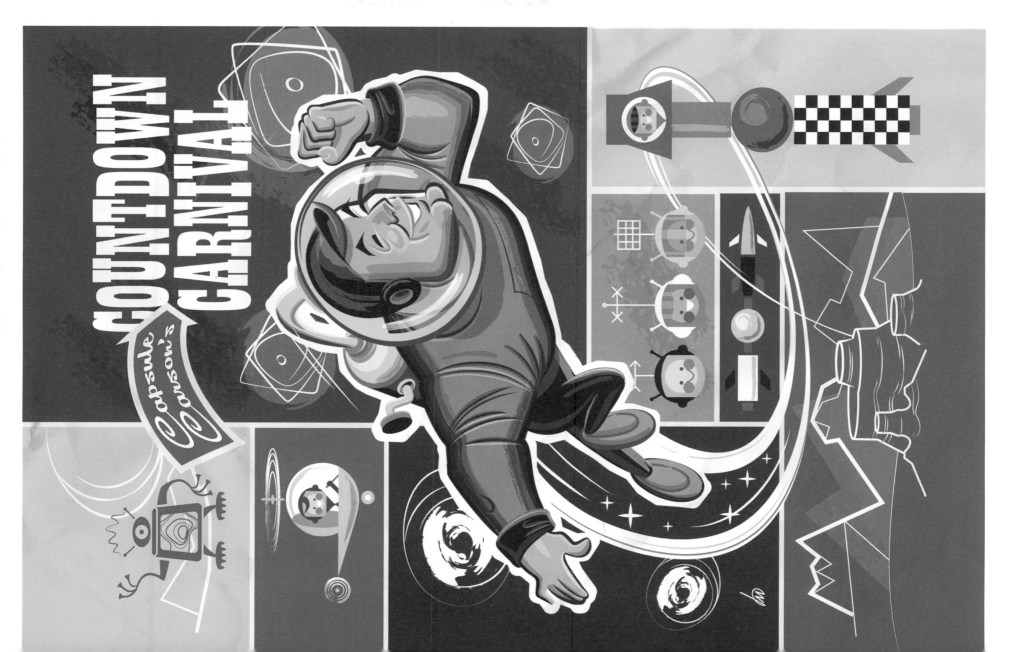

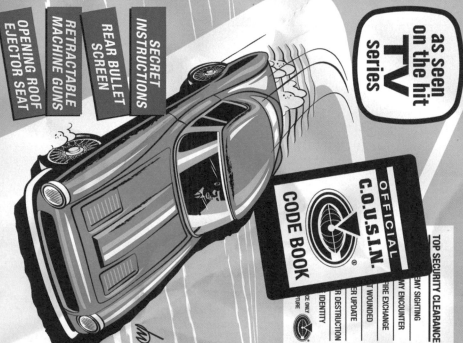

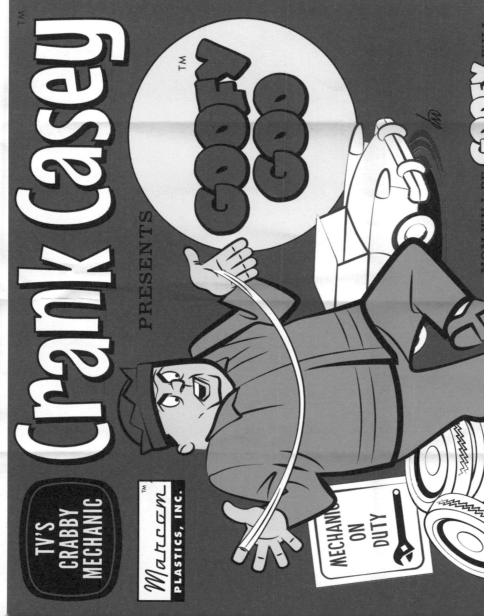

CRASH IT! SMASH IT! TERRIFIC ACTION TOY!

CRASH-O-MATIC ©

1 SNAP TOGETHER THE "SPRING-ACTION" BODY.

2 ROLL BACKWARD TO CHARGE FRICTION MOTOR.

3 LET 'ER GO!

4 CRASH! IT BLOWS APART!

HI-IMPACT DURABLE PLASTIC!

No. 715
U.S. Pat. No. 2,757,441
Other Pat. Pend.

LOADS OF FUN!

JUST 39¢

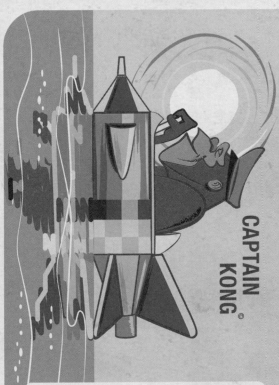

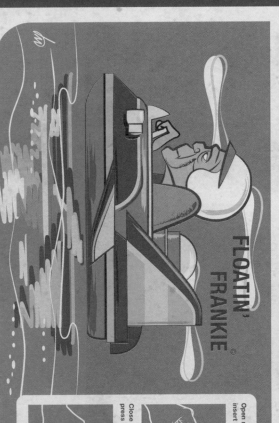

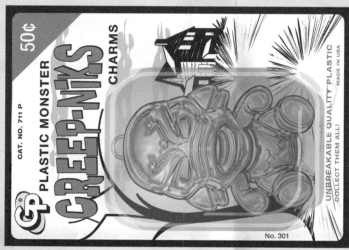
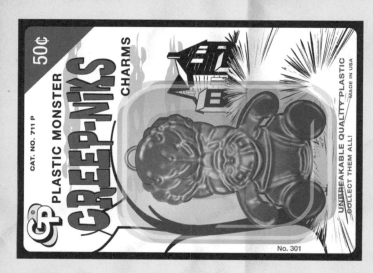

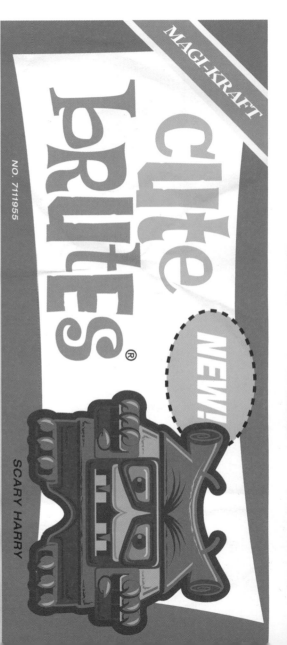

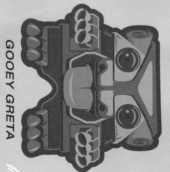
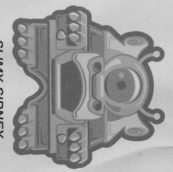

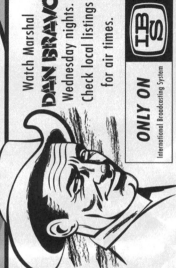

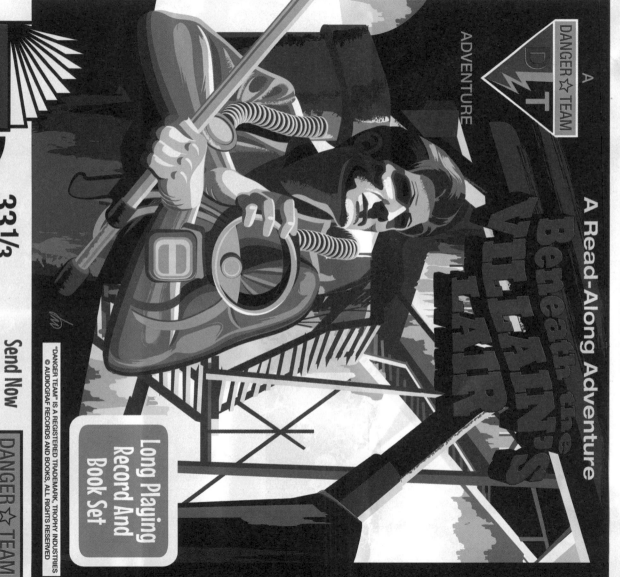

AN ALL-NEW

"DANGER TEAM"

READ-ALONG ADVENTURE RECORD

A Read-Along Adventure Record

A Read-Along Adventure

A DANGER ☆ TEAM

ADVENTURE

Beneath the VILLAIN'S LAIR

24 PAGE BOOK

33 1/3 LONG PLAYING RECORD

Send Now
For Your
Danger Team
Shoulder Patch!

SEE REVERSE
FOR COMPLETE DETAILS

DANGER ☆ TEAM

Long Playing Record And Book Set

TROPHY ®

TOYS YOU'LL PRIZE

audiograf ®

Educational Recordings

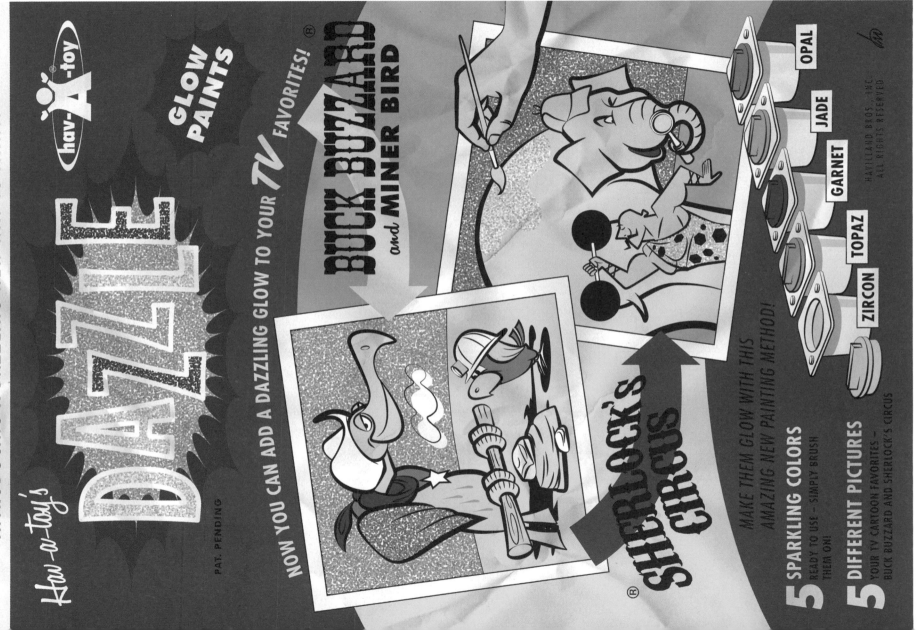

Tentacles OF Doom

YOU CONTROL HIM! MAKE HIM DIVE!

A DIVE TEAM! ADVENTURE SET ®

HERE'S WHAT YOU GET!

COMPLETE RUBBER DIVE SUIT GIANT SQUID

12" RESEARCH CRAFT

KNIFE AND SCABBARD

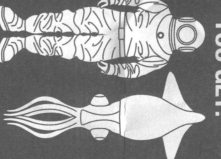

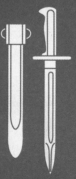

FUNTEK INC. ®

it's new from RALLY TOYMAKERS

DAPPER DERRINGER

DOUBLE BARREL DOUBLE ACTION GUN

$1 98
SUGGESTED RETAIL PRICE

PALM SIZE
PISTOL SHOOTS
MORE THAN
40 ft.

FEATURES...
- **ROTATING DOUBLE BARREL**
- **FIRES TWO CAP-SHOOTING CARTRIDGES**
- **SOFT FLEXIBLE PELLETS**

RALLY TOYMAKERS

PAT. PENDING

MADE IN U.S.A.

NO. 41144

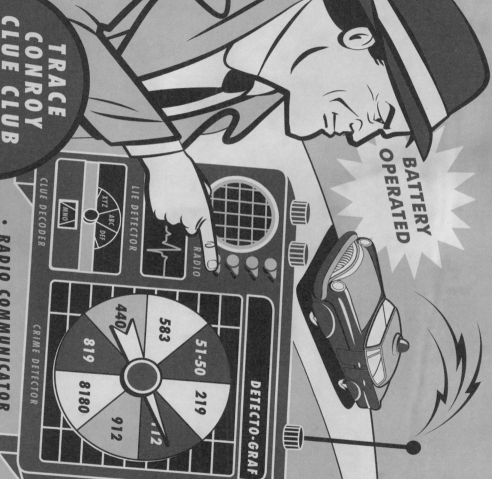

RIFLE & HELMET SET

DOCTOR LIGHTNING JIGSAW PUZZLE

© Whitfield

NEW!

100 piece
14 x 18 inches
every piece
interlocks

59¢

© Capitol Comics Company • Whitfield Printing, Inc.

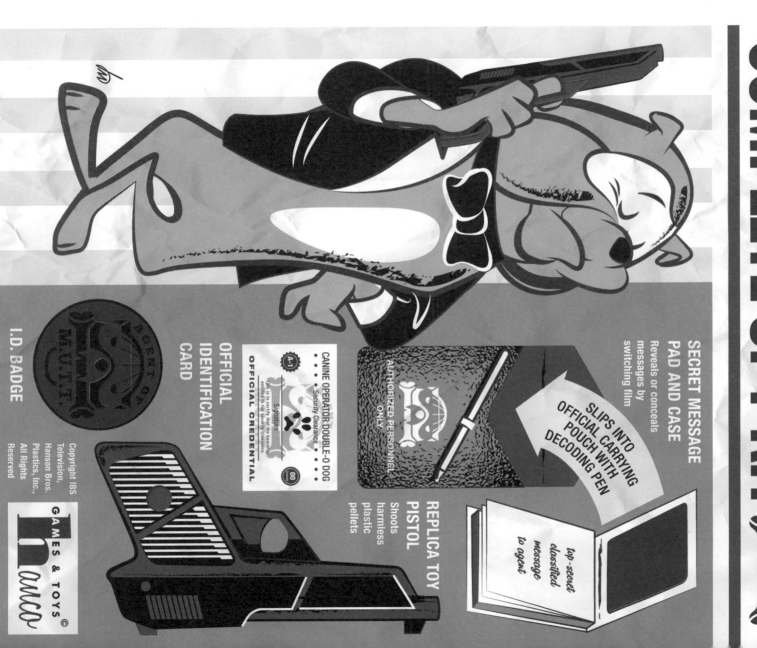

It's TV's secret agent **DOUBLE-O DOG**

COMPLETE SPY KIT

SECRET MESSAGE PAD AND CASE
Reveals or conceals messages by switching film

AUTHORIZED PERSONNEL ONLY

SLIPS INTO OFFICIAL CARRYING POUCH WITH DECODING PEN

top-secret classified message to agent

REPLICA TOY PISTOL
Shoots harmless plastic pellets

CANINE OPERATOR DOUBLE-O DOG
• Security Clearance
A-1
Signature
OFFICIAL CREDENTIAL
This is to certify that the bearer entitled to top security clearance.
00

OFFICIAL IDENTIFICATION CARD

AGENT OF M.U.T.T.

I.D. BADGE

GAMES & TOYS © namco

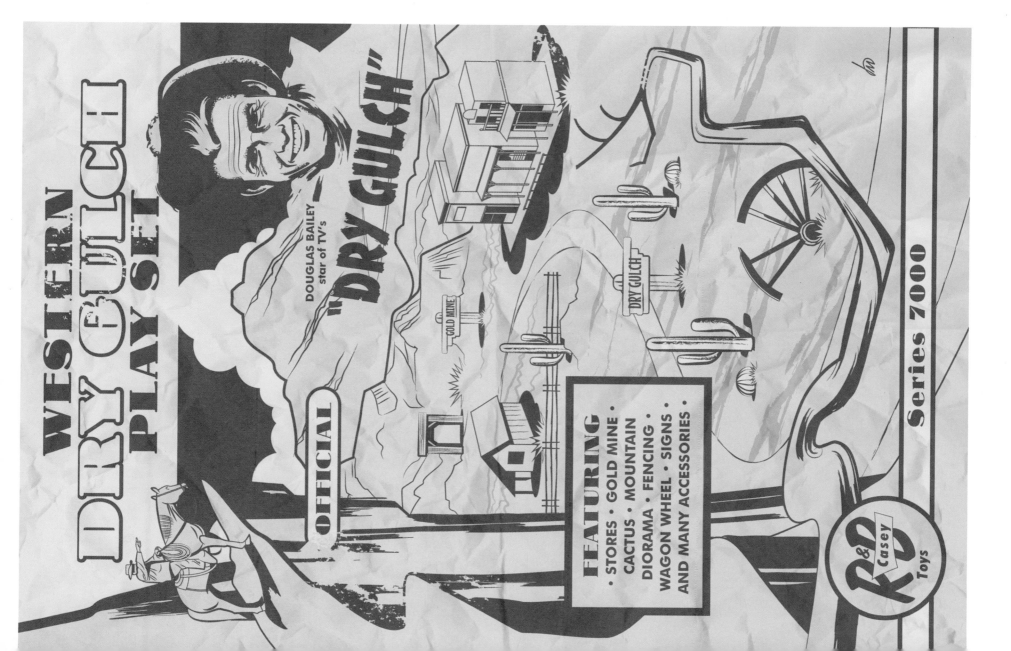

FRANKENSTICKERS
AND BUBBLE GUM

BANNER® TRADING CARD COMPANY

1 Carefully lift and peel sticker from center.

2 Place sticker and smooth wrinkles.

STICK 'EM ON WALLS, BOOKS, DOORS!

SPOOKY! KOOKY!

KICK ME!

5¢

24 MONSTROUS STICKERS IN ALL!

LIKE MY FLAT TOP?

20% FEWER CAVITIES!

SOMETHING'S FISHY!

HOW ABOUT A KISS?

COLLECT THEM ALL!

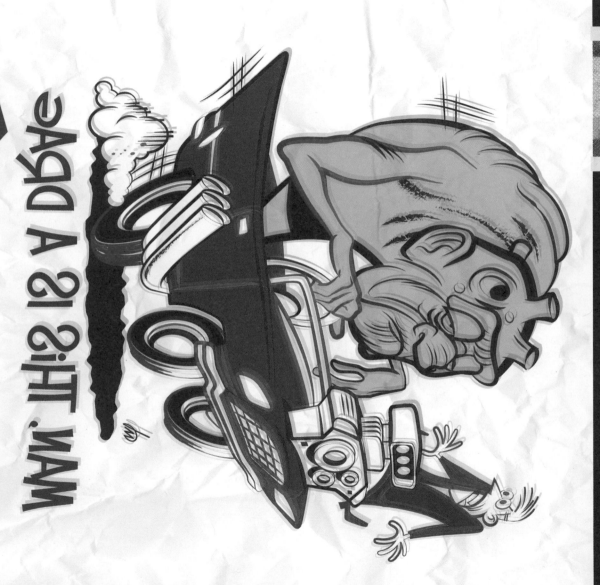

MAN, THIS IS A DRAG

WILD! WACKY! WEARABLE!

GEARGOYLES

Registered Trade Mark

Iron On Transfers

EASILY APPLY THEM TO SWEATSHIRTS, T-SHIRTS,
BLOUSES, APRONS etc.

NON-TOXIC WATERPROOF WON'T SMEAR

59¢

Your Television Pal...

BUMMY STEER

ROCK 'N' ROLL GE-TAR

WITH GENUINE NYLON STRINGS AND MUSIC BOX!

MORNINGSIDE TOYS, INC.

TURN THE CRANK TO PLAY A TUNE!

GO-GO RILLA

FEATURING MECHANICAL DURAMOLD® CONSTRUCTION

ISLAND PLAYSET

JUST LIKE
THE ONE
SEEN ON
THE HIT
CARTOON
SERIES!

SET CONTAINS:

8 IN. GO-GO RILLA "ACTION-ARM" FIGURE
DOCTOR MENLO'S RESEARCH HQ
PLASTIC SPY FIGURES
JUNGLE ANIMALS
NATIVE HUTS
SUPPLY TRUCKS
RESEARCH BOAT
SKULL MOUNTAIN BACKGROUND
PALM TREES

WEL-DON ®
PLASTICS

KISS ME!

ZAP IT TO ME!

10¢ for 25¢

ghoulish groovy spooky kooky ®

stickers

funky frightening fun plus gum

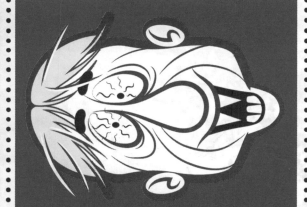

BEWITCHING!

Hair Today!

The Doctor is FAR OUT!

PAIN IN THE BRAIN

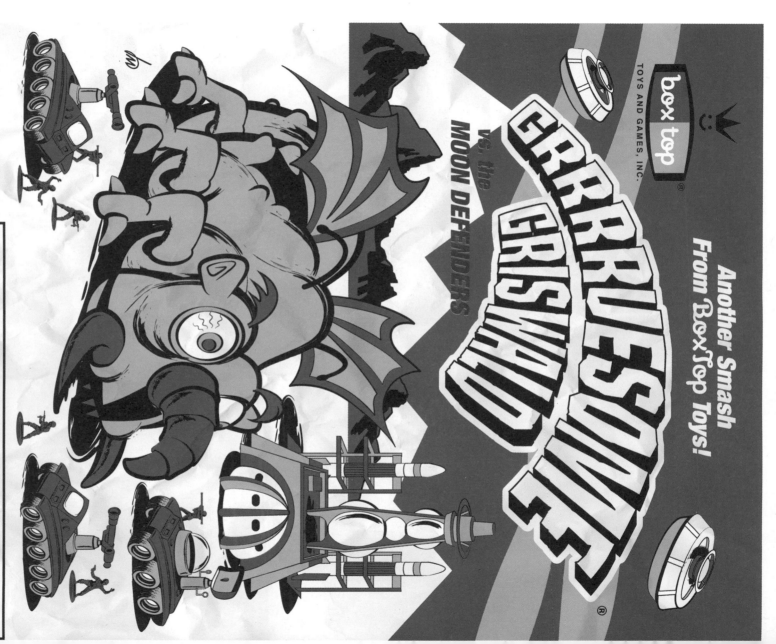

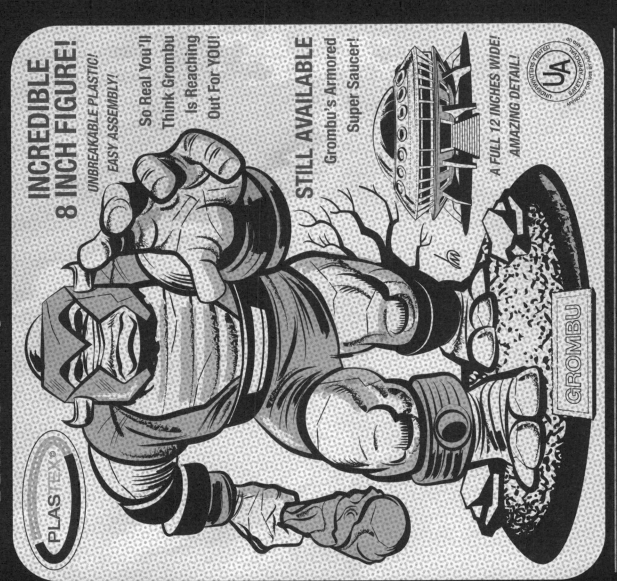

BAFFLING! HORRIFYING! SCIENTIFIC!

NEW!

GROW-A-GOON ©

EDUCATIONAL MONSTER TOY

JUST ADD WATER AND
WATCH 'EM GROW!

SET INCLUDES
• "GOON" HEADS
• GROWING DISH
• SEEDS FOR:
 POPPING EYES
 DRIPPING NOSES
 GAPING MOUTHS

AFTER

BEFORE

MADE IN USA

A FASCINATING EXPERIMENT FOR THE WHOLE FAMILY!

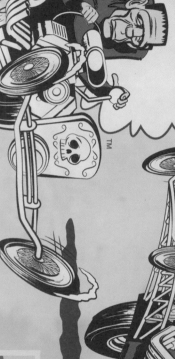
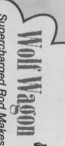

HALLOWEEN
COSTUMES
FEATURING

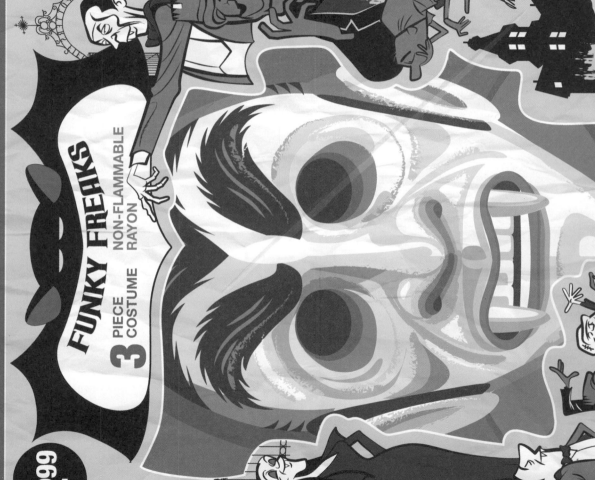

the FUNKY FREAKS

$2⁹⁹

FUNKY FREAKS

3 PIECE COSTUME

NON-FLAMMABLE RAYON

LARGE (12-14)

FITS CHILD 53" TO 58" TALL

ALL RAYON EXCLUSIVE
OF ORNAMENTATION

COLLECT ALL FOUR
SKULLS TO MAKE YOUR ESCAPE!

BEWARE!

funso
TOYMAKERS, INC.

FUN FOR ALL!

We're
waiting
for
you!

MYSTERY MANSION

A SPOOK-FILLED
GAME OF SUSPENSE

ALL NEW *Trixie* FASHION DOLL

HAWAIIAN TWIST

"Twistin' Time" by the Outriggers

ACCESSORIES INCLUDE
• Durable vinyl tiki backdrop
• Trixie lotus print swim suit
• Mini tiki torches
• 45 rpm dance record

(set does not include Trixie and Andy posable dolls)

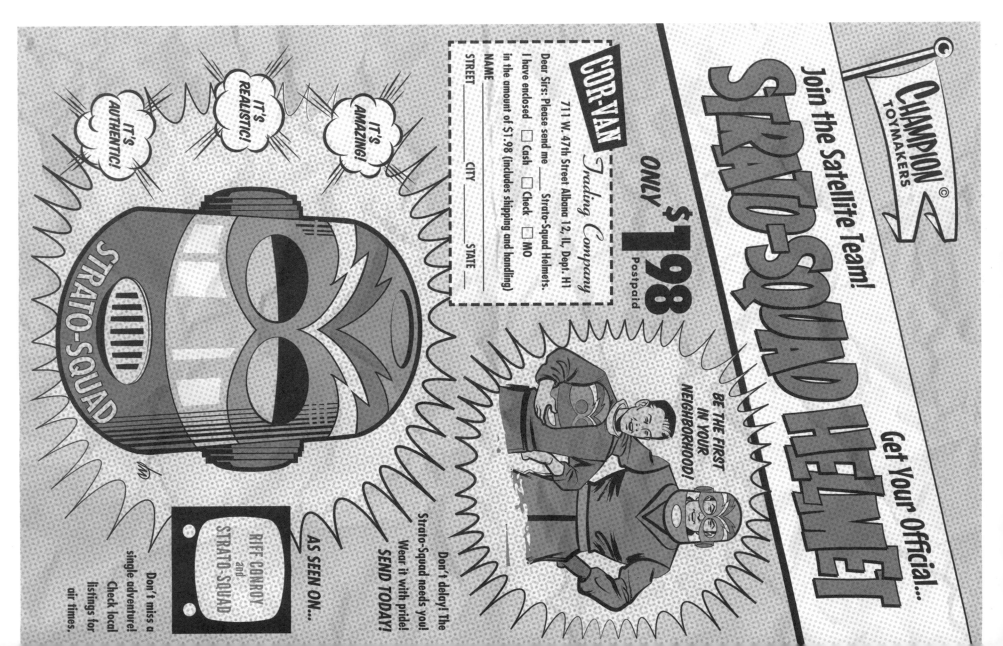

79¢

GHASTLY! GRUESOME

INSTA-GHOUL ®

MAKEUP KIT

INSTA-GHOUL CUSTOM PAINTS

EASY TO APPLY – EASY TO REMOVE

DENKER'S
¼ Custom oz.
Developed
GHOUL RED
enamel
No. 115R Red

DENKER'S
¼ Custom oz.
Developed
GRUESOME GREEN
enamel
No. 114R Green

DENKER'S
¼ Custom oz.
Developed
GHASTLY GRAY
enamel
No. 113R Gray

COMPLETELY SAFE – NON-TOXIC

GRUESOME CLAWS!
AND MONSTER TEETH!

MADE OF SOFT PLIABLE PLASTIC
SAFE • SANITARY • QUICK CLEAN-UP

denker

TOYMAKERS

MASTER THE MENACING SKIES!

7.99 SUG. RET. PRICE

CONCORD

RADAR JET HUNTER ©

TRACK AND DESTROY ENEMY AIRCRAFT

AUTOMATIC LAUNCHER
FIRES SAFE PLASTIC MISSILES!

includes "SkyView" scope

Patented "SkyView" Brings the Action Closer!

CONCORD hobbies ©

CAP BAXTER - STAR CORPS OFFICIAL MERCHANDISE

official "Jugglz" ©
rolling ball PUZZLES

ONLY 25¢

PLASTIC

NEW! SPACE PUZZLES

PERFECT FOR
PARTIES, PRIZES,
GRAB-BAGS, GIFTS

THE ASTRONAUT

Send Your Signals To The Spaceman
"Jugglz" PUZZLE
test your skills
© Titan Toys Incorporated, IBS Incorporated

MAN THE ROCKET

Guide The Crew To The Spaceship
"Jugglz" PUZZLE
test your skills
© Titan Toys Incorporated, IBS Incorporated

...ASION

Send The Missiles To The Target
"Jugglz" PUZZLE
test your skills
© Titan Toys Incorporated, IBS Incorporated

GUIDE THE ROBOT

Balance the Magnetic Satellites
"Jugglz" PUZZLE
test your skills
© Titan Toys Incorporated, IBS Incorporated

Watch
"Star Corps"
Saturdays
at 10 am

TOYS FOR ALL
TITAN ©

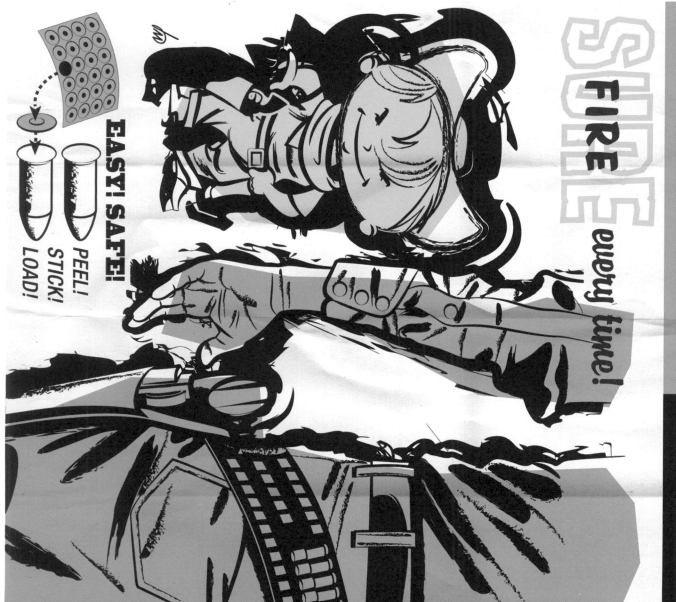

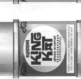

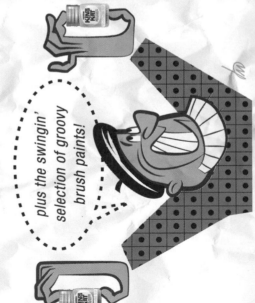

Introducing
Knuckleheader®

THROW LIKE A PRO!

BAFFLE BATTERS WITH SIX DIFFERENT PITCHES!

99¢

"Knuckleheader will teach you the secrets of the Big-Leaguers!"

Wally Barber

**WALLY BARBER
ALL-STAR PITCHER**

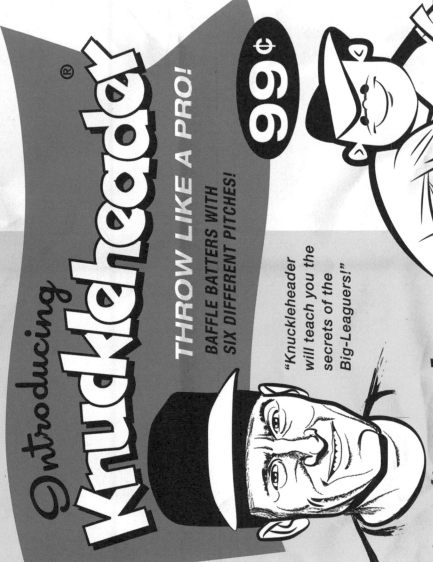

**LEARN
TO THROW...**

- • KNUCKLEBALL
- • CURVEBALL
- • SINKER
- • SLIDER
- • FASTBALL
- • SLOWBALL

*Includes Illustrated
Instruction Manual*

OFFICIAL
Knuckleheader
INSTRUCTION MANUAL
STEP-BY-STEP DIAGRAMS

It's a contest of spooky surprise!

MONSTER MAKER

- Monster moves back & forth between players
- Lightning flash signals players to use directional controls
- He grunts, his arms shoot up

IT'S NEW!

He MOVES along the laboratory walkway.

He reaches the end and turns to FACE YOU!

No. 701 Made in U.S.A.
by THE NORCRAFT COMPANY
FOREST FALLS, 6 VA.

Requires two standard D batteries.

NORCRAFT
Toy Manufacturers ©

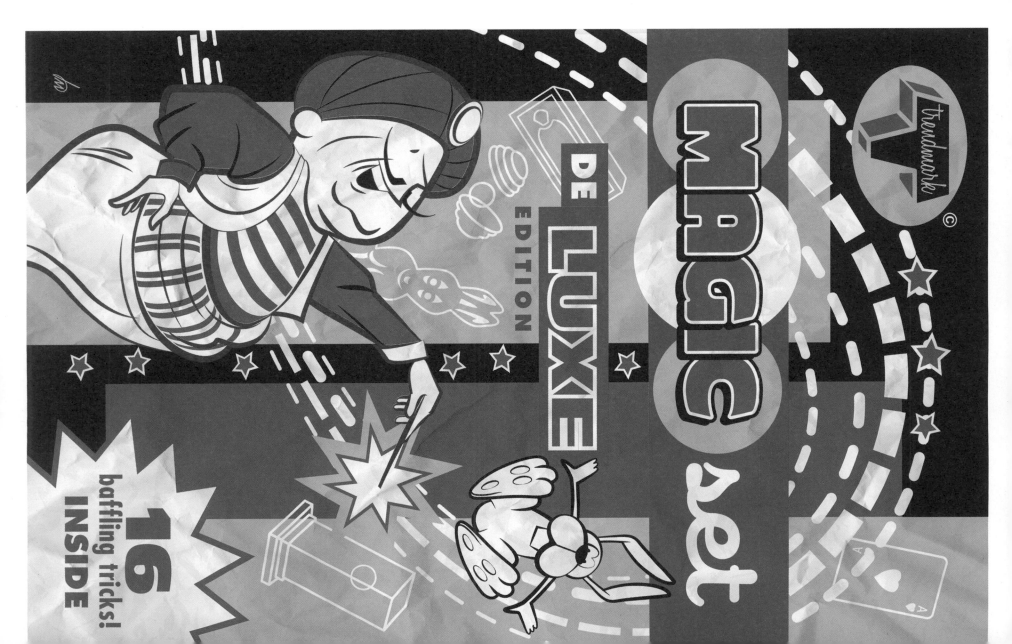

YOU ARE THE MONSTER MAKER!

New From Holaday Toys and Games!

MAGNI-MONSTERS

Use the magnetic pointing wand to create creatures!

REPTILIUS KONGORA LAGOONO

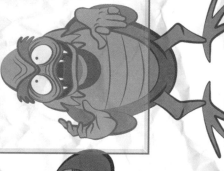
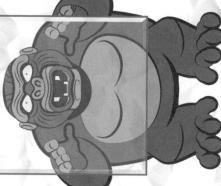

CUSTOMIZE THE INCREDIBLE CREATURES!

It's easy, safe and FUN!

COMES WITH **10** MONSTROUS MUGS
READY FOR YOU TO COLOR!

SIMPLY MOVE THE STYLUS OVER THE
MONSTER'S FACE TO APPLY COLOR!

HERE'S HOW TO MAKE A MONSTER!

Use the stylus to add horns, mustaches, beards, scars, blood and more. When finished, simply shake the magic slate, insert another monster likeness and start again!

COMPLETELY SAFE! NO ELECTRICITY OR BATTERIES REQUIRED!

STILL AVAILABLE
MOON COUPE
▶ FEATURES 12 WORKING PARTS

JUST
$5.99
SUG. RET. PRICE

COMMANDER
MARK MOON
T.M.

U.S.L.E.

LUNAR SCHOONER

SPECIAL FEATURES
▶ "ACTION TRACTION" ROVER WHEELS!
▶ MOTORIZED SPINNING RADAR DISH!

NEW!

JUST
$7.99
SUG. RET. PRICE

ONLY FROM
SOCKO! TOYS

U.S.L.E.

PAT. PENDING

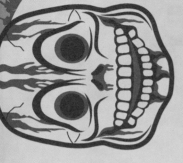

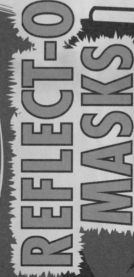
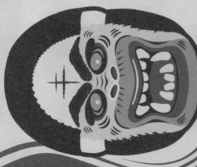

LOOK WHAT *University* TOYS IS COOKING UP FOR HALLOWEEN!

DOUG SKULLERY — No. 21957

WOLF-WEAR — No. 22155

COUSIN FRANK — No. 22707

ZOMBORA — No. 21344

THE FIEND — No. 20204

KONGOR — No. 21955

PRICE .25

REFLECT-O MASKS

Lights Up At Night!
Can Be Seen By Autos
Two Blocks Away!

University TOYS

THEY'RE HERE! *You* make them! *You* mold them!

METAMORPHS

FEATURING the
STONE-AGE LAND Playset

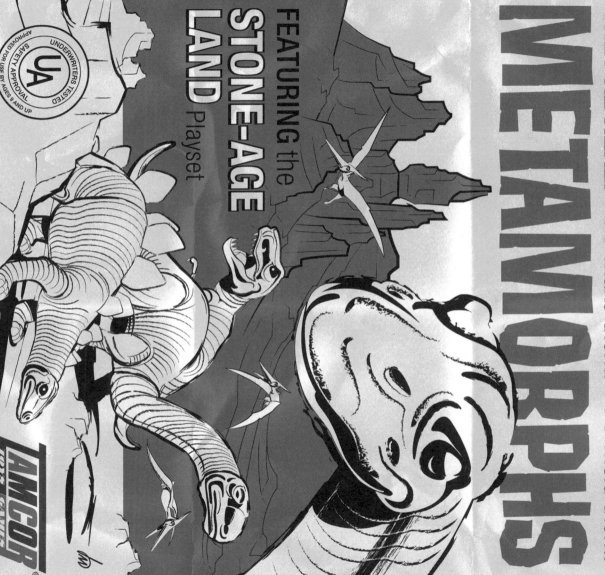

AMCOR TOYS & GAMES ®

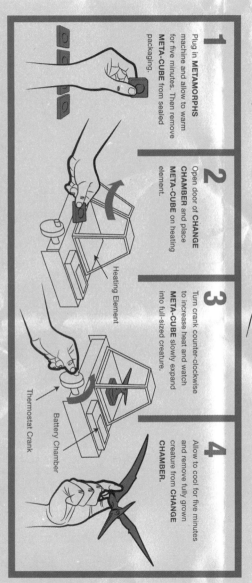

1
Plug in METAMORPHS machine and allow to warm for five minutes. Then remove META-CUBE from sealed packaging.

2
Open door of CHANGE CHAMBER and place META-CUBE on heating element.

Heating Element

3
Turn crank counter-clockwise to increase heat and watch META-CUBE slowly expand into full-sized creature.

Thermostat Crank

Battery Chamber

4
Allow to cool for five minutes and remove fully grown creature from CHANGE CHAMBER.

MAJOR MIDG-IT

RECOMMENDS ALL OF THESE MIDG-IT CANDIES

"THEY'RE BRAND NEW!"

MIDG-IT CHEWS
THREE DELICIOUS FLAVORS

MIDG-IT FUDGE
Chocolate or Vanilla

MILKY CARAMEL
Chocolate or Vanilla

CHEWY NOUGAT
Chocolate or Vanilla

MIDG-IT POPS

CRUNCHY CANDY SHELL WITH A CHEWY MIDG-IT CENTER

ORANGE, LIME, CHERRY CHOCOLATE, GRAPE

CHEWY MIDG-IT CENTER

DELICIOUS **MIDG-IT's** CANDY

NET WT. 1 1/4 OZ.

Reknownly milk chocolate

MIDG-IT MILK CHOCOLATE

JUMBO SIZE

The Original Milk Chocolate
MIDG-IT BAR

MIDG-IT FUDGE
MIDG-IT NOUGAT
MIDG-IT CARAMEL
MIDG-IT FUDGE
MIDG-IT CARAMEL
MIDG-IT NOUGAT

MIDG-IT VARIETY PACK

Six In A Package

Creamy, Chewy
MIDG-IT VARIETY PACK

MIDG-IT ROLL
MILK CHOCOLATE

Eight Chewy Sections

Chunky, Chocolatey
MIDG-IT ROLL

YOU'LL FIND THEM IN YOUR FAVORITE NEIGHBORHOOD STORE!

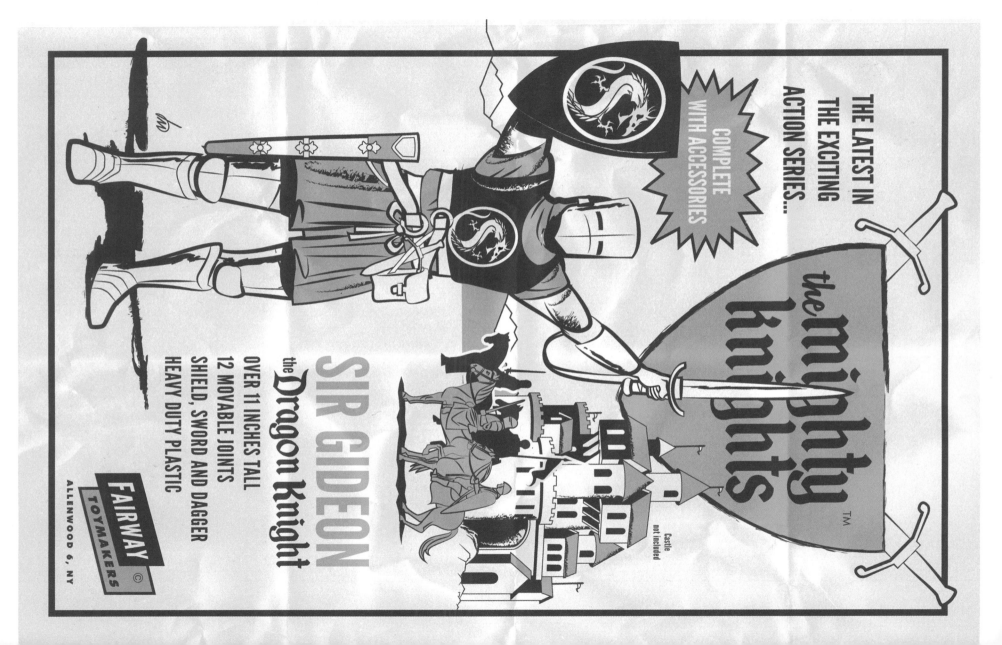

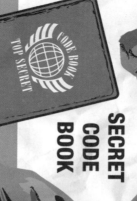

MiKE SECRET PERIL AGENT

TOP-SECRET ESPIONAGE PLAY SET

POSABLE FIGURE

PLACE IN ANY NUMBER OF DYNAMIC ACTION POSITIONS!

SECRET CODE BOOK

CODE BOOK TOP SECRET

PISTOL WITH SILENCER

SUIT WITH CONCEALED POCKETS

MARK PERIL IS READY FOR ACTION! A MAN OF MYSTERY! A MASTER OF DISGUISE! COLLECT ALL 25 ACCESSORIES AND WEAPONS!

TV TOYS & GAMES

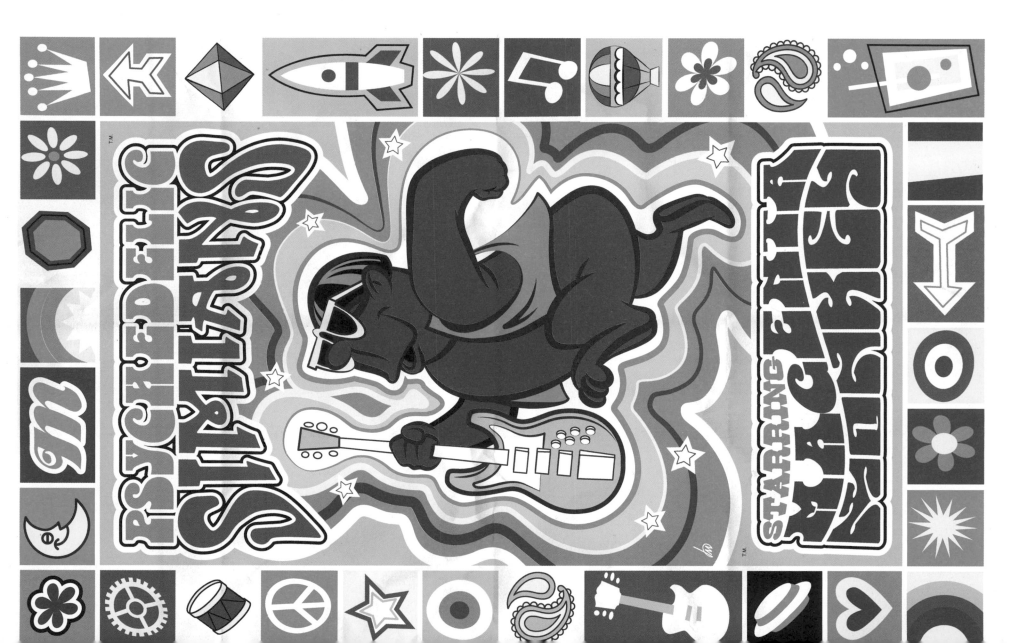

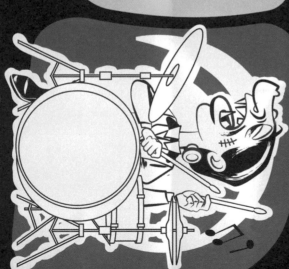

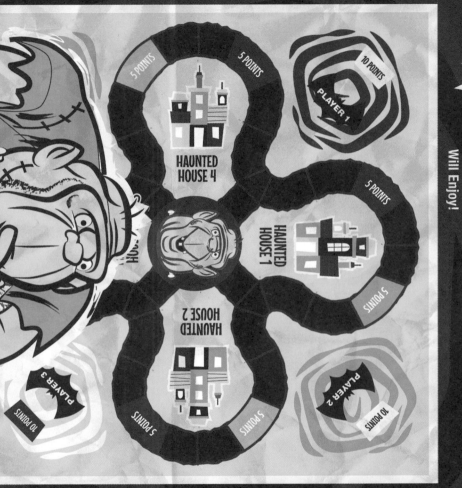

NEW!

TV's Morton THE MONSTER

Spooky, Suspenseful Fun
the Whole Family
Will Enjoy!

GAME

This is a simple
yet exciting
game for 2, 3 or
4 players.
Players advance
past haunted
houses until
reaching
Morton's
smiling face.

AS SEEN ON TV

Contents
include board,
spinning wheel
and four
tokens

RECOMMENDED
FOR
**AGES
5 to 10**

5 POINTS
5 POINTS
10 POINTS
PLAYER 1
5 POINTS
HAUNTED HOUSE 4
HAUNTED HOUSE 1
5 POINTS
HAUNTED HOUSE 2
5 POINTS
5 POINTS
PLAYER 2
10 POINTS
PLAYER 3
10 POINTS

7 SPACES
1 SPACE
5 SPACES
4 SPACES

MADE IN U.S.A.

Copyright And Trademark Banner
Manufacturing, Inc.
Spotsylvania 9, USA

BANNER®
TOYS, INC.

75¢
CAT. NO. 104

ACE TOY

© ACE TOY

SAFE • DURABLE PLASTIC

MONSTER WHACK

EVERYONE'S A WINNER!

grab bags!
giveaways!
prizes!

AS SEEN ON

TV

whack it!

smack it!

Ball Snaps Right Back!

MONSTER WHACK

MONSTER WHACK

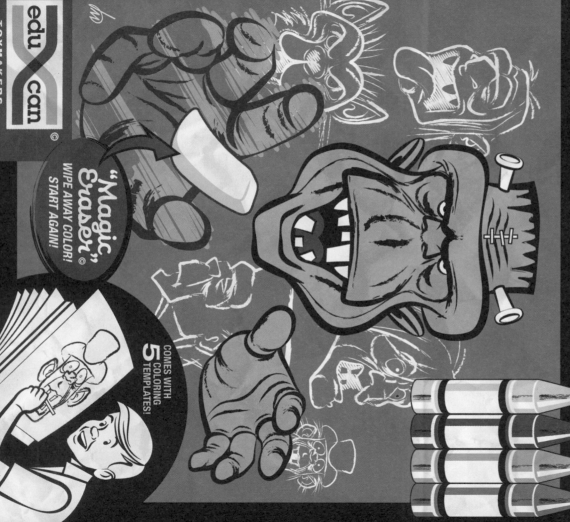

AUTHENTIC MILITARY

JUMP TEAM

U.S. ARMY
PARATROOP
ATTACK! Set

Complete With

U.S. Paratroop Soldiers,
Working Parachutes, Cardboard
Diorama, U.S. Military Planes

KIBLER
TOYS INCORPORATED

sandy ®
FASHION DOLL

NK ®
NEWMAN KAUFMAN
TOYMAKERS, INCORPORATED

Poolside
PAPER DOLL SET

12 different
summer fun outfits

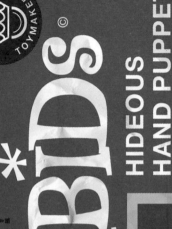
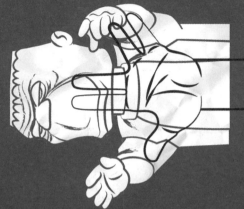

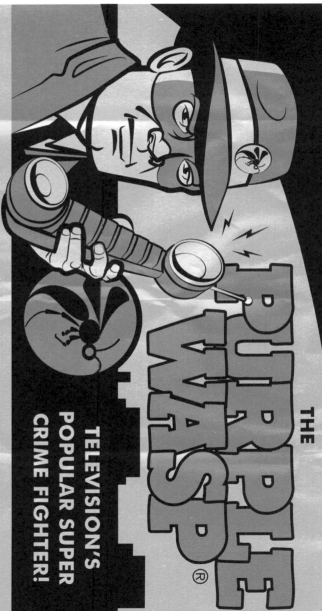

THE PURPLE WASP ®

TELEVISION'S POPULAR SUPER CRIME FIGHTER!

TWO WAY WALKIE TALKIES ®

Official

NO BATTERIES
NO ELECTRICITY
NO TUBES

Just like the one used on the hit TV series!

ELECTRONIC COMMUNICATORS
HEAVY DUTY PLASTIC
EXTENDING ANTENNA
GROUND WIRES
CARRYING CASE

mainway toymakers ®

FOR ONLY
$5.98
Complete with Aerial And Ground Wire

FOR ONLY
$3.98
Comes with Heavy Duty Plastic Case

COMMUNICATOR

PURPLE W

ALSO AVAILABLE
Official
PURPLE WASP WRIST PHONE!

Here it is! Works just like the one used by the Purple Wasp and his operatives!

featuring the

CUSTOM BANKING ™

GRAD PRIX TRACK

1/32 SCALE

AUTO-TASTIC

BLAZING RACERS ™

SLOT CAR RACING SET

THRILLS AND SPILLS ON THE BIG BANKED CURVES!

PRE-ASSEMBLED 2 X 4 FT. TRACK

SETS UP IN MINUTES

2 STEERING WHEEL CAR CONTROLS

BLAZING RACERS ™

WITH TWO 1/32 SCALE

- **THE ELIMINATOR** No. 001955

BLAZING RACERS ™

- **THE METEOR** No. 001957

SPECIAL OFFER FOR YOU!

HERE'S ALL YOU HAVE TO DO!

1. Carefully clip this proof of purchase coupon and sign it on the back.

2. Place it in an envelope with 25¢ in coin and a stamped self-addressed envelope and send to....

THAT'S ALL THERE IS TO IT! You've registered for a chance to win a set of six BLAZING RACERS 1/32 scale slot cars. The set includes the all-new BLAZING RACERS carrying case with room for six slot cars. Write now while this exclusive offer is still available. Winners will be notified by mail.

BLAZING RACERS ™

HOLBECK & DAVIS ™

HD EST. 1932

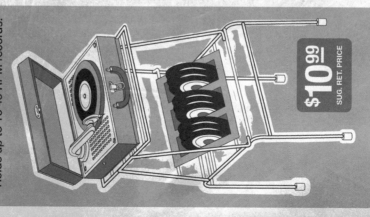

THE GREATEST PLAY SET of the **JET ACE!**

ROCKETS TO THE STARS

LOOK *what you* GET!

- 12-inch Command Center
- Three Missile Launchers
- Three Kronos Missiles
- 8-inch Observation Center
- Radar Station
- 9 3-inch Action Men
- Out-buildings And Barracks

TIMELY HOBBIES

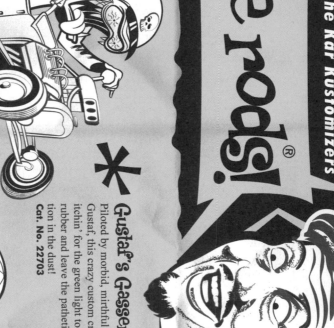
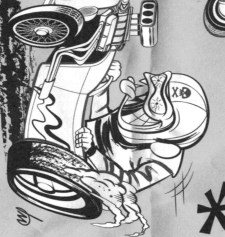

AVAILABLE NOW!

SPORTSTER Sand Tiger T.M.

"HEY FELLAS! The all new, battery motorized Sand Tiger is here! 1/4 scale sports car with 16 movable parts!"

PAT. PENDING

Officially Licensed Sportster T.M.

Quality craftsmanship! Guaranteed authentic in every detail!

SAND SHARK AUTOMOBILE CONCEPT AND DESIGN ARE
COPYRIGHT SPORTSTER MOTOR COMPANY, ALL RIGHTS RESERVED

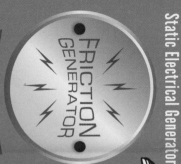

FASHION DOLL®

Misty
AND *Greg*

$**9**^{95}
SUG. RET. PRICE

THE ULTIMATE
MISTY ACCESSORY

*AUTHENTIC
IN EVERY
DETAIL!*

AUTHENTIC

La'venura Capri© MOTOR SCOOTER

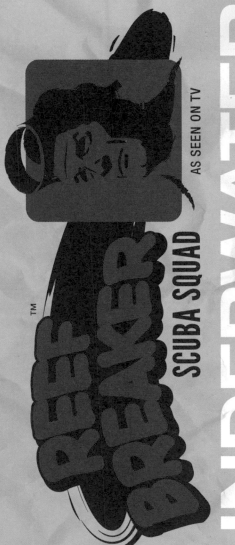

REEF BREAKER™

SCUBA SQUAD

AS SEEN ON TV

UNDERWATER ACTION SET

YOU CONTROL HIM MAKE HIM BUBBLE

CONTAINS:
- Action Diver
- Scuba Suit
- Dive Mask
- Swim Fins
- Oxygen Tank
- Spear Gun
- Watch

Reliant®
MANUFACTURING, INC.

Wondro TOY!

WONDRO'S ALL-NEW MERCHANDISE
INSPIRED BY **TV**'S POPULAR VAMPIRE...

JULIAN KARSWELL

AS SEEN ON THE HIT SERIES Shadow Mansion

SKULL
CANE

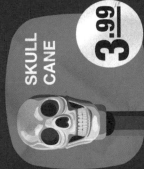

3.99

BAT
RING

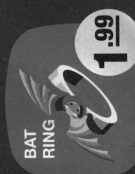

1.99

VAMPIRE TEETH

1.99

Still Available
Shadow Mansion
Mystery Game

5.99

SPINNING TARGETS

METAL DARTBOARD

TM

TV's HUBERT HIPPO

SHOOTING GALLERY

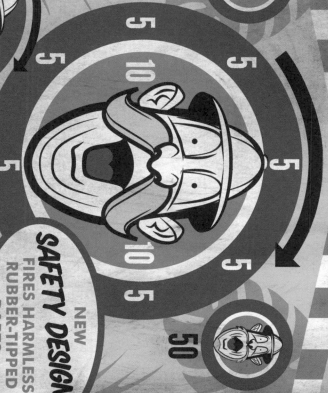

20
40

50

5

5

5

10

5

5

5

10 5

5

50

SPRING-ACTION DART GUNS

NEW
SAFETY DESIGN
FIRES HARMLESS
RUBBER-TIPPED
DARTS

20
40

40
20

NK
NEWMAN KAUFMAN

TOYMAKERS, INC.

WEIRD WORKSHOP ACCESSORY

MONSTER HEADS

MOLD

MOLD YOUR OWN REALISTIC CREEPY CREATURES!

USE YOUR
MONSTER HEAD MOLD
ONLY WITH OFFICIAL
MONSTERGOO®
COMPOUND

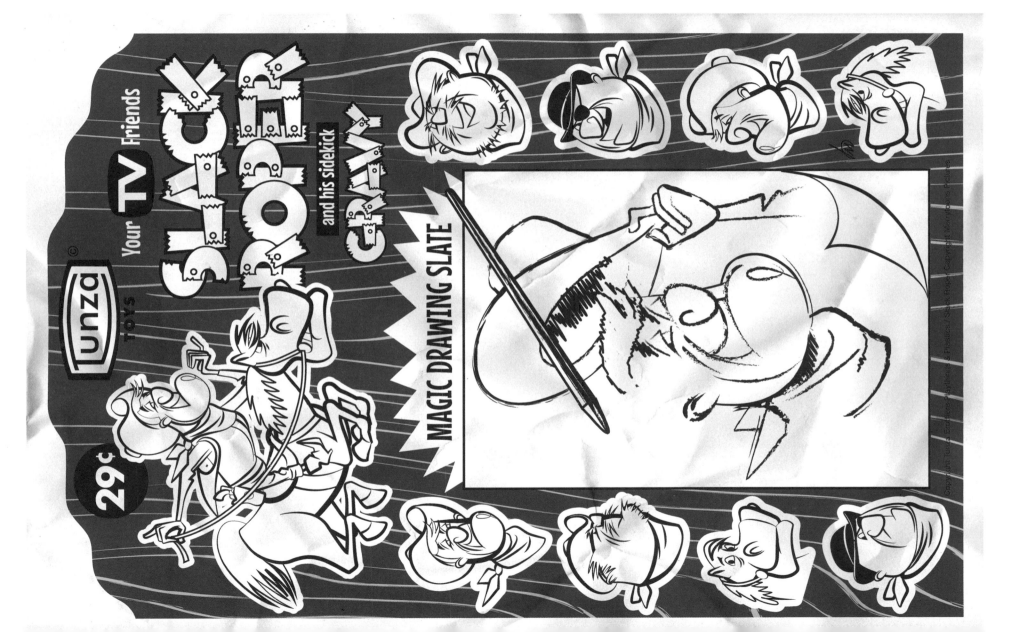

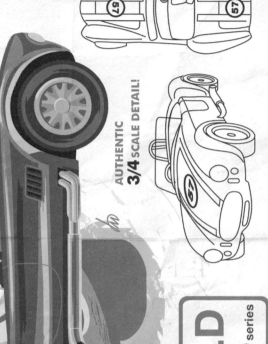

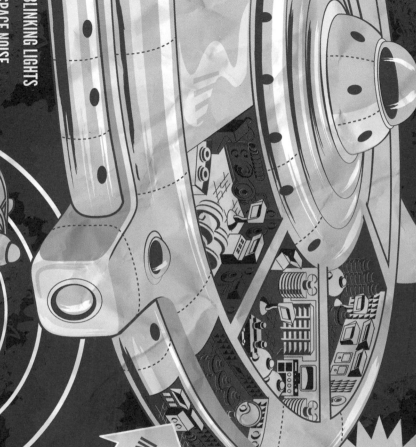

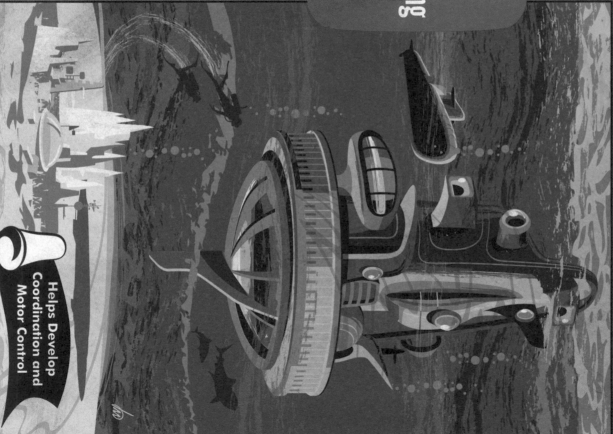

For home
Entertainment

FORTRESS MOVIES

FOR ALL HOME MOVIE SCREENS

is the leader
In SUPER 8

For your
8 MM or 16 MM
**MOVIE
PROJECTOR**

Turn your home
into a real
MOVIE THEATER

Drama

Western

Horror

Science Fiction

Thriller

Cartoons

SUPER 8

**THE CAVERN
OF DR. ZYN**

A "SCUBA FORCE" THRILLER

COMPLETE
SUPER 8
BLACK & WHITE
For Use Only
On SUPER 8
Projectors

TELEVISION AND
THEATRICAL RIGHTS
RESERVED

ORIGINAL COPYRIGHT HELD BY FEDERAL FILMS
LICENSED BY FORTRESS MOVIES, INC.

FORTRESS MOVIES

FOR ALL HOME MOVIE SCREENS

A PRODUCT OF UNITED MANUFACTURING, INC.

Ask Your Dealer
For A Complete Catalog

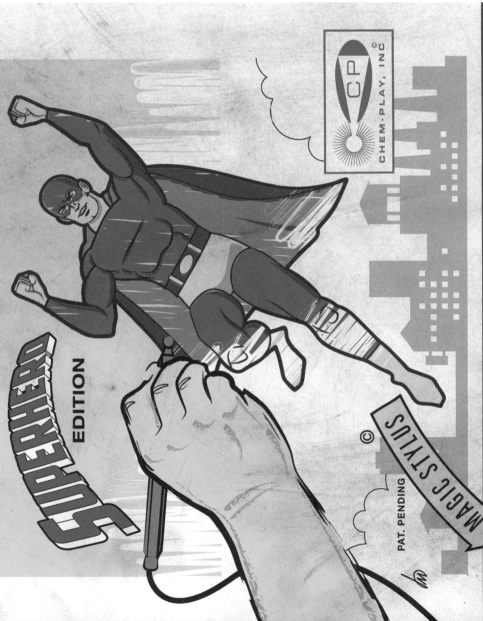

ALL-NEW FROM

SURE-FIRE
A CAMCO COMPANY

OFFICIAL SURE-FIRE RAPID-SHOT

The **Official "RAPID-SHOT"** LEVER-ACTION GUN

Fires By Lever Or Trigger!

CAP SHOOTING

PAT. PENDING

THE GUN USED BY *Jed Brady* ON THE FAMOUS **TV** SERIES

"RIFLE SHOT"®

HARMLESS
NON-TOXIC

NEW!
Gruesome
MONSTER
TATTOOS
COMPLETELY SAFE
39¢

POP STARS 100 CANDID PIN-UPS

FROM **GO** MAGAZINE

TROY'S WILD LIFE
RORY'S SECRET PASSION
RICHIE'S HIDDEN HOBBY
TREVOR'S NEW HOME

SUPER STAR COLOR POP PIN-UPS

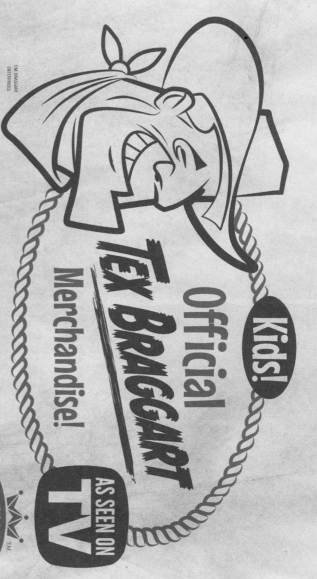

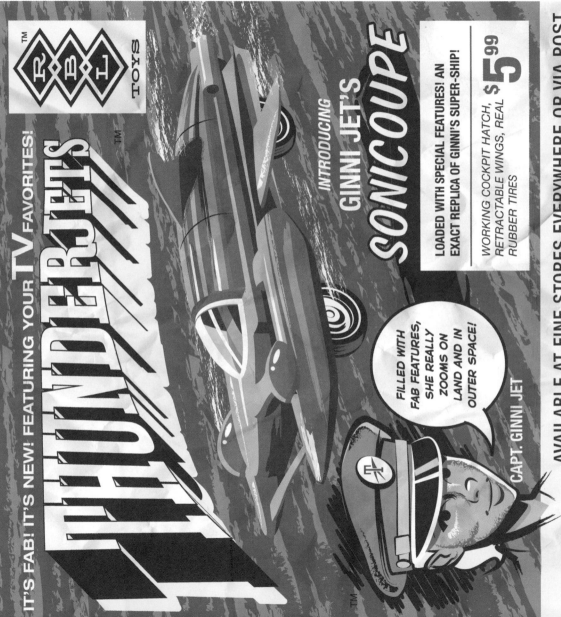
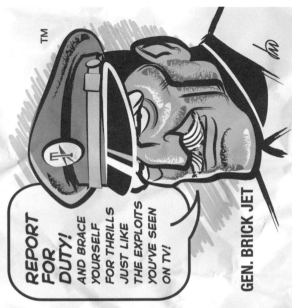
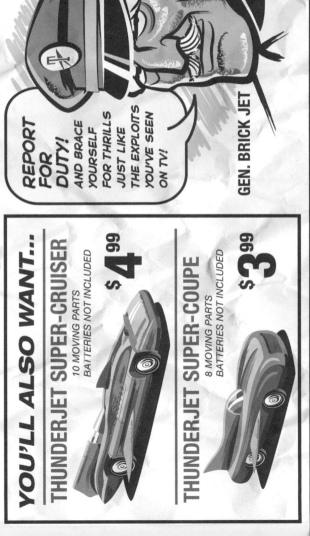

ROCKET PILOTS VS. ALIEN ATTACKERS!

U.F.O. HUNTERS

24 ACTION
piece PLAY SET

Set Includes...
- 4 fighter rockets
- 4 flying saucers
- 4 piece rocket base
- 4 launch pads
- 8 plastic missiles

TOPLINE TOYS

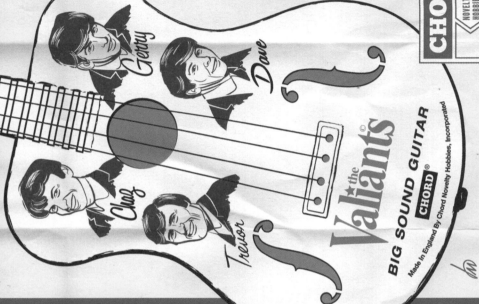

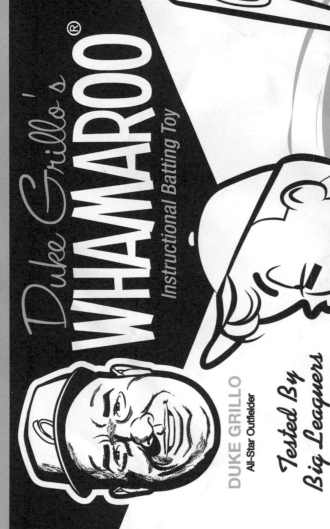

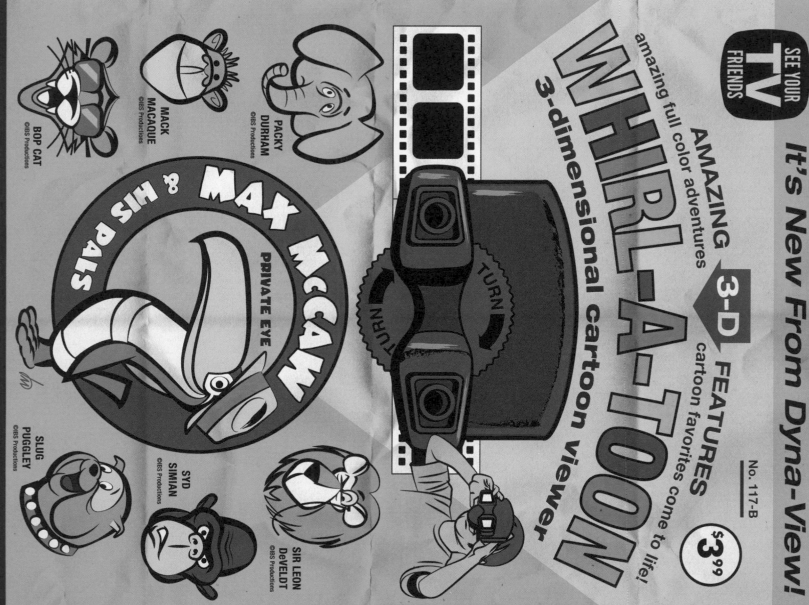

It's New From Dyna-View!

SEE YOUR TV FRIENDS

AMAZING **3-D** FEATURES

amazing full color adventures

cartoon favorites come to life!

WHIRL-A-TOON

3-dimensional cartoon viewer

3-dimensional cartoon viewer

No. 117-B $3.99

TURN TURN TURN

MAX McCAW & HIS PALS

PRIVATE EYE

PACKY DURHAM
©IBS Productions

MACK MACAQUE
©IBS Productions

BOP CAT
©IBS Productions

SYD SIMIAN
©IBS Productions

SLUG PUGGLEY
©IBS Productions

SIR LEON DeVELDT
©IBS Productions

dynamic 3-dimensional images that put you in the show!

**35 AMAZING STEREO SCENES
5 TERRIFIC ADVENTURES**

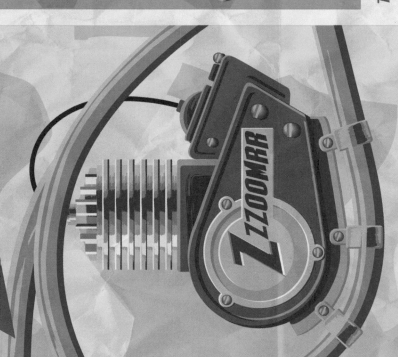

HUGO
TOYMAKERS, INC.

Presents This Year's Most
Amazing Automated Action Toy!

PAT. PENDING

JUST
$10.99
SUG. RET.
PRICE

The MIGHTY ZOROK

**YOU ARE
THE HUNTER!**
Stalk The
Mighty Zorok
armed with the...

DINO-BLASTER!
Spring-Action Dart Gun

PAT. PENDING

Fires rubber-
tipped darts!

ZOROK RANGERS!
YOU'LL RECEIVE THESE EXCLUSIVE CLUB ITEMS!

▼ MEMBERSHIP CARD
▼ OFFICIAL ZOROK BADGE
▼ MONTHLY NEWSLETTER
▼ BONUS ZOROK POSTER

NEW!

**DON'T WAIT!
JOIN THE CLUB!
ACT NOW!**

USE THIS
COUPON
NOW

Enter Your Name and Address